Book 1
Calligraphy
By Scott Landowski

&

Book 2
Oil Painting
By Scott Landowski

Book 1
Calligraphy

By Scott Landowski

1-2-3 Easy Techniques To Mastering Calligraphy!

Calligraphy: 1-2-3 Easy Techniques To Mastering Calligraphy!

Copyright 2017 by Scott Landowski - All rights reserved.

In no way is it legal to reproduce, duplicate, or transmit any part of this document in either electronic means or in printed format. Recording of this publication is strictly prohibited and any storage of this document is not allowed unless with written permission from the publisher. All rights reserved.

Calligraphy: 1-2-3 Easy Techniques To Mastering Calligraphy!

Table of Contents

Introduction

Chapter 1 Calligraphy Terms...6

Chapter 2 What You'll Need..8

Chapter 3 Basic Calligraphy Tips and Techniques..12

Chapter 4 Creating Letterforms..15

Chapter 5 Different Calligraphy Styles..16

Chapter 6 Cursive Script..17

Chapter 7 Roundhand Script...21

Chapter 8 Gothic Script...24

Conclusion..28

Calligraphy: 1-2-3 Easy Techniques To Mastering Calligraphy!

Introduction

I want to thank you and congratulate you for downloading the book, "Calligraphy: 1-2-3 Easy Techniques to Mastering Calligraphy!"

This book contains proven steps and strategies on how to master the art of calligraphy in three easy steps. Each chapter represents a step significant to the mastery of this art.

Calligraphy is commonly known as the visual art of writing. It comes from the Greek words *kallos*, which means beauty, and *graphe*, which means writing. It roughly translates to "beautiful writing". Calligraphy adds a decorative flair to every handwritten word. In fact, more and more people are drawn to the beauty of this unique and ancient art.

This art form uses either a calligraphy pen or brush as a writing instrument. Calligraphy, like most craft, needs patience and practice to master. It requires discipline and respect from the calligrapher.

Practicing calligraphy can bring fun and enjoyment. For some, calligraphy can bring peace of mind and relaxation. With each curve and line drawn brings about a calming and therapeutic effect on the calligrapher. It can serve as an outlet for artistic expression for most artists.

At first, doing calligraphy may be intimidating. But, the art of calligraphy is quite easy to learn. Anyone can create their own masterpieces. If you wish to know more about the art of calligraphy, this book is aimed to help you.

This book will help you get started with your journey to mastering the art of calligraphy. It will tell you the proper and basic tips and techniques. Learn the basic strokes and writing styles. Know some troubleshooting techniques when doing calligraphy.

Thanks again for downloading this book. I hope you enjoy it!

Calligraphy: 1-2-3 Easy Techniques To Mastering Calligraphy!

Chapter 1 Calligraphy Terms

In calligraphy, there are a few important terminologies that you should know. Knowing these technical terms are essential in learning the art of calligraphy. Additionally, these terms will make practicing easier for you. Here are some of the most important calligraphy terms you should be familiar with.

Guide Lines

Calligraphy guide lines, or calligraphy rules, are important in learning calligraphy. These are useful in keeping your writings consistent and evenly spaced. They are also helpful in ensuring that your letters are all level.

- **Ascender Line.** It is usually the topmost guide line. It is the guide line used to as the upper guide line for ascenders.
- **Base Line.** It is the writing line which helps in keeping calligraphy on the same level by determining the base of letters.
- **Descender Line.** This is the bottommost guide line. Its purpose is to mark the bottom parts of the descenders.
- **Majuscule Line.** This guide line determines the top part of upper case letters.
- **Pen Width.** The pen width is basically the width of the pen's edge. It is used to measure the distances of the base line, ascender line, and descender line from the waistline.
- **Waist Line, or x line.** It is the guide line at the top of the x-height. It is used as the upper guide line for minuscule.
- **X-height.** It is simply the distance between the base line and waist line. This guide line is used to determine the height of minuscule, sans the ascenders and descenders.

Letter Parts

- **Ascender letters, or ascenders.** These are letters with strokes rising above the waist line up to the ascender line. Ascender letters include b, d, f, h, k, l, and t.
- **Counter.** This is the white, blank space inside each letter.
- **Descender letters, or descenders.** These are letters with strokes dropping below the base line up to the descender line. Descender letters include g, j, p, q, and y.

Calligraphy: 1-2-3 Easy Techniques To Mastering Calligraphy!

- **Ductus.** The ductus is a guide for the proper number, sequence, and direction of the strokes needed to create each letter.
- **Foot.** It is the terminal, or end, portion of a letter's leg or stem. It is the bent part found on each ends of a letter.
- **Hairline.** It is the thinnest stroke that the pen can make. This stroke is often used as a connector between two letters.
- **Leg.** A letter's leg is either the second or third stroke of some letters. Letters with legs include h, m, n, and u.
- **Ligature.** It is a thin, slightly oblique stroke used to fuse together two or more letters. This is especially used in cursive style of writing.
- **Majuscules.** These are "capital" or upper case letters.
- **Minuscule.** These are "small" or lower case letters.
- **Serif.** It is an additional small stroke, used in gothic script, placed at either the beginning or end of a letter's leg or stem.
- **Stem.** This is a part of a letter which involves the central stroke. Simply put, it is a letter's "backbone".
- **Stroke.** A stroke is any mark made by a pen onto the paper.
- **Swash.** A swash is a flourished stroke.
- **White Space.** These are the areas of the paper that are not filled with ink. These blank spaces include the spaces between letters, lines, and words. It also includes the counters.

Calligraphy: 1-2-3 Easy Techniques To Mastering Calligraphy!

Chapter 2 What You'll Need

To get started with calligraphy, you need to get the necessary tools and materials first. Obviously, you cannot proceed with writing beautiful calligraphy without your supplies. As with most recreational hobbies, it is important to invest in your calligraphy supplies. Be sure to get quality tools and materials. Doing so will make your calligraphy experience much easier and your strokes smoother.

The basic calligraphy materials are more than just pen and paper. You will need more tools to make your calligraphy more meticulously done.

Calligraphy Pens

With calligraphy, you do not use a normal pen. Instead of the usual ballpoint and gel-tip pens, calligraphers use writing tools specially made for the craft.

There are two types of calligraphy pens – dip pens and cartridge-loaded pens. As the name suggests, dip pens use a specialty pen which needs to be dipped in ink to write. On the other hand, cartridge-loaded pens have built-in ink on them. You can choose any of these two to use as your calligraphy pen. Cartridge-loaded pens are easier to use than dip pens. However, you would want to use dip pens if you want the complete calligraphy experience.

For this book, the focus will be on the use of dip pens. A dip pen is composed of two parts – the pen nib and the nib holder.

- **Nibs**

There are many varieties of pen nibs used for modern calligraphy. These different nibs are necessary in creating various calligraphy styles and letterforms.

Italic, or chisel-shaped, nibs are commonly used by most calligraphers. Its sharp edges enable smoother thick-and-thin stroke transitions. Regular italic nibs, however, are tricky to use for beginners because the sharp edges could yank or tear the paper. This is the reason why most calligraphy nibs have pointed tips and softening on the edges.

Stub nibs are another popular choice. Unlike most nibs, stub nibs do not have pointed tips. Instead, they have a square, flat, and "chopped off" tip used for making thicker strokes. Using the stub nibs may be intimidating at first. But, proper practice in using this nib will enable better line-width variation than most nib types.

The cursive italic nib is perfect for regular cursive calligraphy. It resembles an italic nib, but the cursive italic nib has smoother corners and edges. This type of nib creates rounder and smoother strokes than the regular italic nib.

Calligraphy: 1-2-3 Easy Techniques To Mastering Calligraphy!

Oblique nibs are great for left-handed people. Its tip is cut slant to make writing with awkward angles easier. If you are left-handed, the oblique nib will make it easier for you to write from left to right. Also, its unique tip will prevent ink smudging by avoiding hands to touch and ruin the inked words.

These nib types may be overwhelming to use and choose from for a beginner. You can choose to focus on two or more types. Opt for pen nibs with medium flex. The flexible tip will help you as you're still learning about pressure exertion on your writing. Through practice, you can get accustomed to using your own nibs.

Nikko G nibs are perfect for beginners. Platignum and Osmiroid are also nice for budding calligraphers. You can also choose from the calligraphy sets from Parker, Rotring, Filcao, and amongst others. Intermediate and advanced calligraphers could go for Brause Rose and Leonardt Principal nibs.

When purchased, your nibs will still have chemicals and oils on them. You should wipe your nibs when using them for the first time. You can use rubbing alcohol or soap and water to clean them.

It is important to take good care of your nibs to make them last longer. Pen nibs could take from 6 months to a year before wearing out. Clean and store them properly after every use.

- **Nib Holder**

Aside from pen nibs, you will need a nib holder. These are usually made from wood, cork, or plastic. The nib holder is what you will hold while writing. You will learn the proper techniques of pen holding in the succeeding chapters.

Get a nib holder with a general holder feature. This holder has a universal insert, with four prongs to hold the nib.

You need to be careful in inserting the pen nib into the holder. This will avoid ruining your good calligraphy tools. To start, know that the nib should always be handled by its base. Never grab the nib by its tip to avoid hurting yourself through the sharp edges.

You should insert the base of the nib between the holder's outer circle and the inner prongs. Take note that the nib is not placed in between the four prongs. Lock the nib in place until it sits tight into the holder.

Paper

In calligraphy, smooth paper is the best choice. This will enable the nib to glide smoothly without it snagging and yanking the fibers of the paper. Make sure that your calligraphy paper is not too absorbent so that the ink will not bleed through it. Never use textured paper when you are just starting with your calligraphy.

There are special calligraphy pads available. Amongst the popular choices are Clairefontaine, Rhodia, and Tomoe River. These are perfect for hassle-free and uninterrupted calligraphy practice.

Regular printer paper is not a good option for calligraphy. It is prone to nib tears and ink bleeds. However, some laserjet paper can work as a cheaper alternative calligraphy paper.

For calligraphy newbies, it would be great to use a layout paper for practicing. This layout paper is smooth and transparent enough to see your calligraphy guide sheet underneath. The most popular choice for layout paper is the Hahnemuhle layout pad.

Ink

Calligraphy will not be complete without ink. You will need to dip your nib into the ink to start writing. Dipping the nib into the ink is one of the basic techniques to learn in calligraphy – which will be tackled in the following chapters.

For beginners, the most convenient ink to use is either Speedball India ink or Sumi ink. These inks are not too viscous – which is helpful for smooth writing. There are other variations of ink, like Higgins, but it is best to stick with the basic ink types first.

Calligraphy Guide Sheets

Obviously, you will need your calligraphy guide sheets at first. These guide sheets will help you in keeping your writing in straight lines with even spacing. They also come in different writing styles. There are a lot of calligraphy guide sheets you can download online.

Cleaning Tools

The last items to prepare are your cleaning tools. These include a bowl of water, a piece of cloth, rubbing alcohol, and soap and water.

While writing, you may notice that ink is not flowing well in the nib. This could be a result of clogged ink. To wash off the dried ink, you can dip your nib into a bowl of water for a few seconds. Do this several times to prevent ink from clogging into the nib.

Wipe your nib with a soft piece of cloth. Make sure that the cloth you are using is not fibrous. You would not want cloth fibers to get caught into the edges of the nib.

After every use, clean your nibs using rubbing alcohol or soap and water. Never leave your calligraphy tools dirty and unwashed.

Ideal Workspace

Calligraphy: 1-2-3 Easy Techniques To Mastering Calligraphy!

Your workspace is as important as your calligraphy tools. Make sure that your workspace is sufficient and comfortable enough. A cramped-up space may not be ideal. Calligraphy requires you to move your arms and shoulders freely. You must have enough room so that you will not knock down on anything as you write.

Additionally, a messy workplace will not be ideal for calligraphers. If your tools are all over the place, your calligraphy experience will become stressful. Remember, discipline is a key attribute for calligraphers.

Calligraphy: 1-2-3 Easy Techniques To Mastering Calligraphy!

Chapter 3 Basic Calligraphy Tips and Techniques

Now that you have gathered all your tools and equipment for calligraphy, you are now ready to start. But, do not try intricate and complicated styles yet. You should know the basics first before working on some serious calligraphy styles.

The art of calligraphy exhibits patience and discipline. You cannot be good at calligraphy if you are restless and impatient. For you to succeed in this art, you should follow each step correctly and do not be in a hurry.

Holding the Pen

Holding your calligraphy pen properly is a critical factor for getting beautiful letterforms. Use your thumb and forefinger to gently grip it – the same way you would hold an ordinary pen. Be careful not to hold it too tightly. If you do, your hand will be prone to fatigue which causes shaky handwriting.

Lay your middle finger behind, or in between the pen and paper, to add support to the pen while writing. Relax your whole hand while writing. You can allow your fingers to brush or drag lightly into the paper. However, do not let them drag too much on the paper to prevent smudging the paper with ink.

Make sure that the tip of the nib is faced away from your body. The pen should be held at a constant 45-degree angle – a fundamental part for calligraphy writing.

Ink Dipping

Dipping the pen nib into the calligraphy ink may not sound so hard. But, there is more to it than just dipping your pen into the jar of ink. The key to correct dipping is the sufficiency of the amount of ink.

If you put too much ink into the nib, chances are, ink will overflow and drip out from the tip. If too little ink is in the nib, your strokes may seem scratchy. This will also mean constant interruptions due to constant ink dipping.

The ideal amount of ink should reach ¾ of the nib, from the tip to the base, or above the nib's vent hole. Dip your pen into the jar of ink gently to avoid ink splatters.

Practice Strokes

Calligraphy may seem intimidating at first. All those loops, curves, and lines may not look good the first time you do them – which is normal. Therefore, before proceeding with creating letters and words with calligraphy styles, you should first practice the basic pen strokes.

To start, dip your pen into the ink and hold it at an angle of about 45 degrees. Position your pen with an unchanging angle. Allow the tip of the pen to lay flat

Calligraphy: 1-2-3 Easy Techniques To Mastering Calligraphy!

onto the paper. This will let you write with more line variations. It will also prevent the corners of the nib to scratch and tear the paper.

Unlike regular ballpoint pens, do not push your calligraphy pen against the paper. Doing so could damage your nib. It could also snag the paper and spatter the ink all over. Most beginners are accustomed to using ballpoint pens. That is why they have difficulty in adjusting to using a calligraphy pen. The proper way of using the calligraphy pen is to let it glide smoothly into the paper. Do not put too much pressure on the pen and on your paper while writing.

It's time to try your calligraphy pen. You can make lines, curves, and loops as much as you can. These will be your "practice strokes". It is acceptable if you write slowly and hesitantly in the beginning. You are just starting to get comfortable with using your pen.

Make sure that the nib does not turn as you practice your strokes. The tip of the nib should always point at the same direction throughout your writing. Doing so will provide consistency with your script. This is the same writing technique you should apply throughout your calligraphy practice.

Keep going on with your "practice strokes" until you get well-acquainted with your pen. Practicing your basic strokes will help you determine the width variations you can create based on the direction of your stroke, pen position, and pen angle. Knowing how to create thick and thin line variations will provide better effects for your calligraphy.

Practice your interaction with your calligraphy ink. Practice re-dipping your pen into the ink to prevent it from running out. Also, remember to dip the pen in water every occasionally, to clean it.

Main Strokes

Now that you are done with your practice strokes, you can proceed with the main strokes. In calligraphy, there are two main strokes – downward stroke and upward stroke.

As a rule of thumb in calligraphy writing, you exert pressure on your downward strokes and none on your upward strokes. The downward strokes are usually thick and heavy. On the other hand, the upward strokes are fine and thin. This should be consistent on every stroke you create.

Start by making downward strokes. Again, make sure that the tip of your pen is laid flat on the paper. Place it on the top line and start moving your pen downwards onto the base line. You can make these downward lines straight or a bit slanted.

For the upward strokes, you can try by making multiple curves which go up and down. Place your pen on the base line of your sheet. Start moving your pen upwards onto the top line. Then move it back again onto the base line. With this

Calligraphy: 1-2-3 Easy Techniques To Mastering Calligraphy!

exercise, you will see the difference in line weights between a downward stroke and an upward stroke.

If you have noticed, almost all techniques in calligraphy require you to make practice strokes. It is because your calligraphy writing will improve only through practice. Always keep in mind that there are no shortcuts in calligraphy. Try the easier strokes first and master them, before you proceed with more intricate strokes and styles.

Calligraphy is an art – it cannot be rushed. You need to have patience and discipline to be successful. It will be tempting to carry on with the harder letters and styles. But know that in calligraphy, you will not learn if you skip a step.

Always keep in mind that practice is highly important. It might be tedious and tiresome, but once you make your first calligraphy work you'll know that your hard work is all worth it.

Chapter 4 Creating Letterforms

Now that you have learned all the basics of calligraphy writing, you can now advance into writing your first letters and words. You may notice that calligraphy has become easier now that you have practiced the basic strokes. In this chapter, we will be discussing different calligraphy styles that you could try.

In forming your letters, you must be aware of the proper number, order, and direction of your strokes – or the ductus. Following the ductus for each letter will help you come up with great-looking letterforms. Get a copy of a ductus diagram to guide you on the proper way of forming your letters. Following the ductus for each letter will help in being successful in calligraphy.

Be patient in trying to learn to write each letter. Know how each letter is created and how they could be connected to form words. You can try writing random words, your name, your initials – basically, anything! You don't have to think about what calligraphy style to use. Not yet.

Keep on practicing your letters and words until you feel comfortable. You know you are ready with advanced techniques when you don't have to think about your writing. Remember, calligraphy is a form of art and meditation. It does not need overthinking. Your mind should be at ease and cleared up. Let your hand do the thinking.

Calligraphy: 1-2-3 Easy Techniques To Mastering Calligraphy!

CHAPTER 5 Different Calligraphy Styles

There are a lot of calligraphy styles to choose from. Each calligraphy style is unique and different. You can choose which you would like to learn or which one suits you best. It is advisable to stick to one calligraphy style first. Master each stroke for each calligraphy style before you move on to other complicated styles. If you are patient enough, you would be able to learn all calligraphy styles in no time.

To help you start with mastering a certain calligraphy style, you can download printable worksheets and guide sheets online. There are a lot of worksheets in different calligraphic styles you can choose from. Getting your own copy of your preferred calligraphy style will guide you in mimicking and practicing with its basic letterforms.

The most common calligraphy styles include: Cursive script, Roundhand script, and Gothic script. There are other calligraphy styles which are only variations of these three. The following chapters will give you tutorials on each. Each calligraphy style is distinct. This means that different pen strokes are needed to achieve them.

As you master each style, you may want to create your own calligraphy style. Do this only if you are done with the basic styles. Here is a brief description and a few tips about the basic calligraphy styles.

Calligraphy: 1-2-3 Easy Techniques To Mastering Calligraphy!

Chapter 6 Cursive Script

The cursive script is perfect for the romantic calligrapher. Channel your inner Jane Austen through this calligraphy style. It is described to have loopy letters and flowy writing. It is usually seen as fonts used in wedding invitations because of the subtlety of the design.

The cursive script is the easiest calligraphy style to learn. In fact, it is nearly identical with the cursive writing taught for elementary students. Most letters in this calligraphy style consists of only two strokes to make. For beginners, the cursive script is the best calligraphy style to start with. It is because of its simplicity and less complicated strokes. Cursive script is also great for practicing consistent and uninterrupted writing.

Lowercase Alphabet

Get your guide sheets ready and start first with the lowercase alphabet of the cursive script. You might notice that most letters require only one stroke. You wouldn't even have to lift your pen!

You can go ahead and write your usual ABC's. However, to make practicing more efficient, it is better to categorize your letters first into groups – upward stroke letters and curved stroke letters.

Upward stroke letters are letters which begin with an upward stroke when written. B, f, i, h, j, k, m, l, n, r, p, s, u, t, v, w, y, x, and z are all upward stroke letters. On the other hand, curved stroke letters begin with a curved stroke when written. These include the letters a, e, g, c, d, o, and q.

- **Upward Stroke Lowercase Letters**

 Let us start with the upward stroke lowercase letters. If you have your guide sheets with you, you will notice that there is a definite number and direction strokes for each letter. Follow these strictly to achieve cursive letterforms.

 If you are hesitant in starting with a pen, you can sketch the letters with a pencil. Then, simply follow each pencil mark with your pen. Your first letters might not be as good as you expect them to be. Some might be shaky in appearance. Or, your writing might not be consistent. If any of these happen, do not get frustrated! Remember that you are just starting out. Your letterforms will look better with practice.

 If you don't have a guide sheet with you, do not worry. In this chapter, we will be discussing the step-by-step process on how to make the basic letters. Let us start with the letter 'u', since it is the easiest.

Calligraphy: 1-2-3 Easy Techniques To Mastering Calligraphy!

Position your pen at the base line. Guiding your pen upward, make a slightly curved line up to the waist line. Make a downward stroke going back to the base line. Glide your pen again upward into the waist line. Then downward again up to the base line. End the letter 'u' with a slight curl on the last stroke. Repeat making the letter 'u' until you made a complete row. Make sure to be consistent with your strokes and always follow your guide lines.

See, calligraphy isn't so hard to learn. Aside from the letter 'u', you can also try making letters i, j, m, n, r, v, w, and y. These have strokes like that of the letter 'u'.

Let us proceed with harder letters. The letter 'h' is a great example. Place your pen at the base line. Make an upward stroke up to the ascender line. Curve your pen a bit to the left to create a tiny loop for your 'h'. Glide your pen downwards going back to the base line, passing through the first line you made. At this point, you should have created the stem, with a tiny loop, for your letter 'h'. Your next step is to create a small arc from the base line up to the waist line. To finish your letter 'h', guide your pen downwards up to the base line and create a small curl at the end. Repeat this letter until you finish one row of them.

Work your way through the rest of the cursive script lowercase letters. Stick to the proper strokes and proper pen direction. Have patience in practicing them over and over.

- **Curved Stroke Lowercase Letters**

Curved stroke letters are bit complicated than the upward stroke letters. These letters are usually curvy and loopy. Again, fix your attention to the direction of strokes for every letter. You can still use your pencil to sketch the letters if you are not yet comfortable with your pen. However, you may want to skip this step when you go on with your calligraphy practice.

For curved stroke letters, the letter 'o' is the easiest. Unlike upward stroke letters, curved stroke letters start at the waist line. Make a small oblong for your letter 'o'. Draw an arc to the base line and guide your pen back to your starting point at the waist line. As with any letter of the cursive script, end you letter 'o' with a tiny curl pointing to the right. Repeat doing this letter several times until you mastered it.

Let us try a harder letter – the letter 'g'. Same with your letter 'o', start with the waist line going to the base line and going back to the waist line – making a small 'o' in the process. The next thing to do is to create a downward stroke from your waist line to the descender line. Curl the pen a bit to the left and make an upward, slightly diagonal, stroke going a bit above the base line. This last stroke should cross the downward stroke you made. Make more of this letter until you mastered it.

Calligraphy: 1-2-3 Easy Techniques To Mastering Calligraphy!

Finish all the other curved stroke lowercase letters. Make sure that you repeat doing each letter multiple times to familiarize yourself with them.

For your last step in making lowercase cursive script, you can try writing the whole alphabet by yourself. You can also create a few words if you want. Focus on how each letter could be combined.

Uppercase Alphabet

Now that you got the hang of writing your lowercase letters, you may now proceed with your uppercase letters. In calligraphy, the uppercase letters have more elaborate details than lowercase letters. They are bigger and they have more loops and lines into them. If you are intimidated with these uppercase cursive script letters, you can always sketch them first with pencil. Later, you should try them without the aid of a pencil.

Let us start with the simplest amongst the uppercase letters – the letter 'L'. This one is the easiest because all you need to do is to guide your pen to glide into the paper. The letter 'L' has a simple flow that even beginners can follow.

Start at a point slightly below the majuscule line. Slide down to the waist line and back to the majuscule line – making an open letter 'o'. Create a downward stroke, learning a bit towards to the right, until you reach the base line. Once you are at the base line, arc to the left and back to the right to create a small loop to your letter 'L'. Finish it with a curved line sweeping to the right.

Practice your uppercase letter 'L' multiple times. Do not be afraid of restricting your hand with small loops. For uppercase letters in cursive script, it is better to slant your letters a bit to the right to give it a more refined look. The bigger, loopier, and more slanted your letters are, the better.

For harder uppercase letter, you can try the letter 'R'. Position your pen at the majuscule line. Make an arced, downward stroke up to the base line. End this stroke with a tiny curl facing left. Lift your pen and start another stroke with the waist line as your new starting point. This point should be just beside your first downward stroke. From the waist line, make a big curl facing left and moving up to the majuscule line. Make another big curl, this time pointed at the right, moving downwards the waist line. Now, you should have made a letter 'P'. To finish your letter 'R', make another curve to the right moving down to the base line. As with any cursive script, always end with a slight curl.

You just finished your first fancy letter in calligraphy. It's not too hard, is it? Repeat this letter a couple of times. Again, do not fear your loops and curves. Finish the rest of the uppercase alphabet.

The last step to creating the cursive script is to combine lowercase and uppercase letters. Try writing your name with this calligraphy style. Do this a couple of

Calligraphy: 1-2-3 Easy Techniques To Mastering Calligraphy!

times. Notice how you combine the letters together. Practice the proper use of ligatures for connecting your letters.

There you go! You have already mastered the cursive script. This style is fancy and impressive but easy to learn. As you practice, you will notice that writing will become easier and faster. For the next chapters, you will be trying on other writing styles that are more detailed.

Calligraphy: 1-2-3 Easy Techniques To Mastering Calligraphy!

Chapter 7 Roundhand Script

Roundhand script is a combination of the cursive script and print letters. It is less curvy and loopy than a cursive script. And it is a bit fancier than print lettering. Using the roundhand script will also make writing words easier. This is because each letter does not need to be combined by a ligature.

Unlike the cursive script, the letters of the roundhand script usually require two or more strokes to complete. This will make it a little tricky to master. This calligraphy style is highly versatile. You can alter your strokes to make each letter look more modern or classier.

We will start learning the roundhand script like what we did on the cursive script. Get your worksheets ready. We will start with the lowercase letters, uppercase letters, and combination of both.

Lowercase Alphabet

For lowercase letters of the roundhand script, the letters are divided into two groups: downward stroke letters and curved stroke letters. If you may notice, there are not upward stroke letters for the roundhand script. Note that the groupings of letters vary for every calligraphy style.

- **Downward Stroke Lowercase Letters**

 The downward stroke letters are letters which begin with a downward stroke. It includes the letters b, f, h, i, j, k, l, m, n, p, r, s, t, x, and z. It is always easier to start with the downward stroke letters.

 For the roundhand script, you will be doing a lot of broken apart letters. This means that when writing a letter, you should lift your pen up for every stroke. Broken apart letters are harder to write because of the constant interruptions in your writing. Unlike the cursive script, the roundhand script does not involve continuous pen movement.

 We'll start with the easiest downward stroke lowercase letter, the letter 'h'. Position your pen on the ascender line. From this point, guide your pen downward until it reaches the base line.

 Now, lift your pen and position it at a point on the downward stroke that is right below the waist line. Make an arc going up towards the right up to the waist line. To finish your letter 'h', make a downward stroke parallel to the first downward stroke you made earlier. Finish your letter 'h' with a slight curl. Do this letter for a couple of times until you get the feel of it. Notice that the letters of the roundhand script are less loopy and fancy than the cursive script.

Calligraphy: 1-2-3 Easy Techniques To Mastering Calligraphy!

Let us proceed with a harder letter. Let us try the letter 'k'. Create a downward stroke from the ascender line to the base line – like the first stroke you did for the letter 'h'. Lift your pen and place it to a point on the downward stroke just below the waist line. Make an arc going up, facing right, to the waist line. From this point, make another arc, this time facing left, back to the downward stroke between the waist line and the base line. To finish your letter 'k', make a diagonal stroke that is sweeping downward to the right. Repeat this letter a couple of times.

You can try the rest of the roundhand script lowercase alphabet. Practice as much as you can until you are comfortable with writing each letter.

- **Curved Stroke Lowercase Letters**

Curved stroke letters for roundhand script include the letters a, c, d, e, g, o, q, u, v, w, and y. These letters start with a curved stroke, hence their name.

We always start with the easiest letters. For the curved stroke letters, we will start with the letter 'c'. This letter consists of two strokes for the roundhand script. Place your pen on the waist line. Make an arc, to the left, downwards to the base line. End this stroke with a small curve. For the second stroke, return your pen to the starting point. Make a tiny arc towards the right.

Practice doing this letter multiple times. Many letters in the roundhand script uses the basic stroke of the letter 'c' as its first stroke. The letters d, e, g, o, and q have the same first stroke as the letter c.

Let us try the letter 'q'. This letter also has two strokes. The first stroke of the letter 'q' is the same as the first stroke of the letter 'c'. Since you have mastered the letter 'c', doing this first stroke will not be hard for you.

For the second stroke, place the pen back to the starting point. Draw a straight downward stroke until you reach the descender line. Repeat this letter several times, adding flourished stroked with each try. The letter 'q' is like other letters of the roundhand script. Once you already mastered this letter, you can do the rest!

There you go. You have completed the lowercase alphabet for the roundhand script. It was not so bad, was it? Try writing the whole alphabet before you proceed with the uppercase letters.

Uppercase Alphabet

The uppercase alphabet of the roundhand script is more detailed than the lowercase alphabet. These letters are more curved and bigger. Each stroke, especially downward strokes, are more flourished than those found in lowercase letters. Most uppercase letters of the roundhand script start with a curved stroke. So, there is no need to classify them anymore. We could go ahead and work our way through the alphabet.

Calligraphy: 1-2-3 Easy Techniques To Mastering Calligraphy!

As usual, we always start with the easiest letter. In this case, we will start with the letter 'C'. Position your pen at the majuscule line. From this point, create the first stroke by arcing your way down, around to the right. Finish this stroke with a flourished stroke to give it more flair. Bring your pen back up to the starting point for the second stroke. This time, create an arc going down, around to the left, creating a flourished stroke like the first one you did.

As you may have noticed, the uppercase letters are all about the flair. Each stroke is ended with a flourished stroke. Make more of this letter before you proceed with the hard ones.

Let us try the letter 'K'. Place your pen on the majuscule line. Create a small letter 'c' from the majuscule line to the waist line. End the first stroke with a fancy curl. Return your pen to the starting point and make a downward stroke to the base line, with the end curling a bit. Lift your pen and place it to a point just below the majuscule line, to the right of the downward stroke. From this point, curl up to the majuscule line and down to the intersection between the waist line and the downward stroke you made earlier. Create an arc down, and to the right, up to the base line – making a fancy curl at the end. Finish the rest of the uppercase alphabet.

The last thing to do is to combine your uppercase letters with your lowercase letters. Practice how you could connect the letters. Try writing several phrases and words to get you accustomed with the roundhand script.

There you have it. You have just completed your second calligraphy style. Way to go! See, calligraphy is not at all complicated. All you need is to break down each letter into its basic strokes. Now that you have learned the basic calligraphy styles, you are now ready to learn more complicated ones.

Calligraphy: 1-2-3 Easy Techniques To Mastering Calligraphy!

Chapter 8 Gothic Script

Alas! You have reached the last basic calligraphy style for you to learn. The gothic script is, by far, the most difficult and most intricate calligraphy style. However, it is also the most striking calligraphy style there is.

What makes gothic script more complicated is the small strokes needed to complete a single letter. Good thing though, the flourished strokes in the gothic script alphabet are similar for each letter – which makes it somewhat easier. Let's start!

For your warm up, practice with the special strokes for the gothic script. These strokes include the downward serif and the upward serif.

Let's start with the downward serif. Place your pen at a point slightly above the waist line. Make sure that your pen is positioned in a 45-degree angle. This pen position will enable a thick pen stroke in the paper. From your starting point, drag your pen a bit downward, in a diagonal motion to the right. That should create a wide pen stroke that would form what looks a little diamond on the paper. Practice doing this several times.

For the upward serif, place your pen at the base line. Again, make sure that it is positioned at a 45-degree angle. By doing this, you could have a thin stroke. From your starting point, slightly drag your pen upward to the right. Do this several times until you master the upward serif.

Now that you have learned the special strokes for gothic script, you can start with the letters of this fancy script.

Lowercase Alphabet

If you have your guide sheet with you, you may notice that the gothic script is really intricate and highly detailed. You will need to be meticulous with your strokes. The key to being good in this calligraphy style is to focus on how the strokes go. Practice each letter religiously until you know which order of strokes you prefer. The lowercase alphabet of the gothic script is divided into two: downward serif lowercase letters and upward serif lowercase letters.

Additionally, the gothic script makes use of various pen position and pen angles. This will create nice line width variations for your letters.

Practicing with the gothic script may be harder than other calligraphy styles. If you are intimidated with how intricate the letters are, you can start by sketching the letters first with a pencil. You can just follow the pencil sketches with your pen afterwards.

Calligraphy: 1-2-3 Easy Techniques To Mastering Calligraphy!

- **Downward Serif Lowercase Letters**

Earlier in this tutorial, you have practiced how to create the downward serif stroke. The consonant letters b, f, j, h, l, m, n, k, p, r, t, x, v, and y and the vowels u and i begin with this special gothic stroke.

As usual, always start with the easiest ones. Let us start with the letter 'u'. Position your pen on a point just above the waist line. Guide your pen downward, and diagonally to the right, until you reach the waist line. From this point, create a normal downward stroke to a point just above the base line. Lift your pen and reposition it in a 45-degree angle. Make a downward serif stroke until you reach the base line.

For the next part of your letter 'u', lift your pen again and place it to a point above the waist line. Make sure that this point is with the same level as your first point and to the right of your point at the base line.

You should repeat the first two strokes you made. Again, make a downward serif stroke up to the waist line. Make a normal downward stroke until you reach a point slightly above the base line. Draw a downward serif stroke to connect it to the base line and the first part of the letter 'u' you made earlier. To make the bottom of your letter 'u', place your pen at the second downward stroke you did. Make a downward serif to the right down to the base line. End it with a downward serif pointing upward and to the right.

You just finished your first gothic letter. Observe that the letter 'u' is made up of basic strokes. Other letters – m, n, v, w, and y – have similar strokes like the letter 'u'.

The letters of the gothic script consist of straight and connecting lines. Learning gothic script may be harder than the other two calligraphy styles. However, with enough practice, you would become comfortable with the gothic script.

We will now proceed with the letter 'k'. Start with your pen placed on the ascender line. Make a small downward serif, slanting to the right, up to a point just below the line. Make a downward stroke up to a point above the base line. Finish your first stroke with a downward serif stroke, slanted to the right, until you reach the base line.

Lift your pen up and place it on the intersection between the waist line and the downward stroke, but the pen should be at a 45-degree angle. Create the top of your letter 'k' by making a long upward serif stroke. End up at a point above the waist line. Then, make a downward serif stroke to the waist line.

Lift your pen again and place it in a point below the waist line at a 45-degree angle. Make a connecting upward serif stroke until you reach the last stroke you made.

Calligraphy: 1-2-3 Easy Techniques To Mastering Calligraphy!

For the last part of your letter 'k', reposition your pen to the middle of the last line you drew, still at a 45-degree angle. From this point, make a diagonal line, going to the right, to a point above the base line. End the letter 'k' with a small upward serif. Repeat this letter until you become accustomed to it. Finish the gothic script alphabet and practice them before proceeding with your uppercase letters.

- **Upward Serif Lowercase Letters**

The consonants c, d, g, q, s, z and the vowels a, e, o all begin with the upward serif/connecting stroke. If you are a complete beginner, it's best to use a pencil to sketch out the letters. That way, you'll feel a little more confident and you can just follow the lines using a pen.

We will make a letter 'c', since it is the easiest. Place your pen, at a 45-degree angle, on a point just above the waist line. Make an upward serif going towards the right. Lift your pen and place it horizontally on the lower point of your upward serif. From this point, create a thick downward stroke to a point just above the base line. Then you can draw a downward serif until you reach the base line. Draw the ends of your letter 'c' by going back to your first upward serif stroke. Place your pen at a 45-degree angle on the upper part and make a small sweeping horizontal stroke to the right. Finish it off with another upward serif stroke from your base line. Make your rows of letter 'c' until you mastered it. The letter 'c' is the basic letter you can use to make other upward serif lowercase letters.

Let us make a letter 'g'. First, make your usual letter 'c'. To create your letter 'g', make a longer horizontal line at the top. Lift your pen and place it horizontally on your last stroke and make a downward stroke going halfway between the base line and the descender line. You have created the tail part of your letter 'g'. At this point, you should have something that looks like a letter 'q'. To finish your letter 'g', end the tail part with a downward serif and an upward serif – both going to the left.

Practicing your letter 'c' and 'g' can help a lot in learning gothic script. It is because other letters of the gothic script have the same strokes as these two basic letters. Use your letter 'c' and 'g' as your reference letters as you go through the rest of the alphabet.

Uppercase Alphabet

Here we go to the last part of your gothic script tutorial – the uppercase letters. The uppercase alphabet of the gothic script is quite elaborate and detailed. You would need a lot of patience in practicing.

Calligraphy: 1-2-3 Easy Techniques To Mastering Calligraphy!

In the uppercase letters of the gothic script, your curved strokes need to be bigger. Your downward strokes are more flourished. Lastly, most uppercase letters have a skinny downward stroke as an accent to each letter. Let's start with some practicing this skinny downward stroke.

To start, place the tip of your pen on the majuscule line. This time, the pen should be angled vertically. Drag your pen downwards until you reach the base line. Notice how thin this new stroke is. Create a few of this until you are satisfied.

Mastering the gothic script will be easier if you have a guide sheet with you. It will show the proper order of each stroke you create.

Let us start with the letter 'P'. Position your pen on a point just below the majuscule line and create and upward serif up to the line. Draw a downward stroke past the base line. Lift your pen and place it on the downward stroke at a 45-degree angle. Make sure that this point and the starting point are on the same level. Draw an upward stroke reaching the majuscule line. Make a slightly diagonal, sweeping stroke going to the right and past the majuscule line. Make a downward stroke to a point just below the waist line. Your next move is to create a slight curve, to the left, until you reach the base line. Draw a thick horizontal stroke past the downward stroke. The last step is to create a skinny downward stroke that is near and parallel to your downward stroke.

The uppercase letters of the gothic script have the same strokes. Make your way through the rest of the alphabet and practice your uppercase letters. Do not stop until you are satisfied by the way your letters look.

The last step is to put your lowercase and uppercase letters all together. You can write anything you want for your practice words and phrases. There you go! You just mastered the last basic calligraphy style. That wasn't so bad, was it?

Conclusion

Thank you again for downloading this book!

I hope this book could help you to become a professional calligrapher. I hope that you enjoyed your calligraphy practice as well.

You have just finished a whole course of calligraphy classes. The next step is to make your own calligraphy projects. From invitations, to name tags, and to cards, calligraphy script is highly impressive to look at. Have fun with your calligraphy alphabets. You can even create your own font if you want.

Just remember that the best tip for mastering calligraphy is through practice. You will only get better by focusing on the letters or strokes you are having difficulty at. Try to practice each day, even only for a few hours. The effort you put in practicing will make a difference in your craft.

Finally, if you enjoyed this book, please take the time to share your thoughts and post a review on Amazon. It'd be greatly appreciated!

Thank you and good luck!

Book 2
Oil Painting

By Scott Landowski

1-2-3 Easy Techniques To Mastering Oil Painting!

Oil Painting: 1-2-3 Easy Techniques To Mastering Oil Painting!

Copyright 2017 by Scott Landowski - All rights reserved.

In no way is it legal to reproduce, duplicate, or transmit any part of this document in either electronic means or in printed format. Recording of this publication is strictly prohibited and any storage of this document is not allowed unless with written permission from the publisher. All rights reserved.

Oil Painting: 1-2-3 Easy Techniques To Mastering Oil Painting!

Table of Contents

Introduction

Chapter 1: Oil Painting Overview..33

Chapter 2: Fundamentals of Oil Painting..35

Chapter 3: Master the Art of Mixing Colors...39

Chapter 4: Monochromatic Painting..41

Chapter 5: Paint Local Colors Using Analogous Colors...........................43

Chapter 6: Paint a Portrait...51

Conclusion...59

Oil Painting: 1-2-3 Easy Techniques To Mastering Oil Painting!

Introduction

I want to thank you and congratulate you for downloading the book, Oil Painting: 1-2-3 Easy Techniques to Mastering Oil Painting!

This book contains proven steps and strategies on how to overcome different challenges in oil painting. The step-by-step approach of this book will guide you in achieving a successful start in your oil painting practice.

This book covers the fundamentals of oil painting, the principles of mixing oil paint colors and developing an image. The simplified steps are a guarantee that even beginners will be able to relate with the process.

Thank you and we hope you enjoy this book.

Oil Painting: 1-2-3 Easy Techniques To Mastering Oil Painting!

Chapter 1. Oil Painting Overview

Oil painting has been around for centuries. It makes use of a kind of paint that has creamy and smooth consistency, and can produce vivid colors. When one speaks of oil painting, the image of great artists and their masterpieces also come to mind. This is a very old painting practice and though there have been a lot of changes in the materials being used, the techniques have not changed that much.

An oil paint consists of dry colored powder mixed with a drying oil as the binder; hence, the name. Some people create their own oil paints but you can buy ready to use oil paints from stores. Ready to use oil paints normally come in tubes. The oil paints are combined to make various colors.

Oil paints take time to dry. This attribute has its benefits and drawbacks. One of the benefits of using a slow drying paint is that you can refine and adjust the image that you are painting before it dries. Oil paints also make it possible for you to correct some parts of your painting that you want to remove. You can remove an image by using a wet rag, a palette knife or a rubber squeegee.

The disadvantage of using oil paints is that it can be difficult to apply different colors next to each because they can mix if you are not careful in applying them. Once a painting is finished and is completely dry a varnish is applied to protect the painting.

Mastering the art of chemistry is essential to achieving the proper effects for your work. This complexity of oil painting makes it fun and challenging to work with.

Basic Information About Painting Using Oil Paints

Most of the commercial tube paints are ready to use. In some instances, you may use a solvent or a medium to modify the paint. The solvent dilutes the paint and the medium adds oil back to the paint to make it creamy. As you spend more time working with oil paints, you will notice that some colors take more time to dry than the other colors.

After an oil paint, has been applied, it develops a skin of dry surface through the chemical process called curing. This process protects the surface of the painting. Take note though, that the surface might be dry but the entire painting itself will takes months before it becomes thoroughly dry.

Oil Painting: 1-2-3 Easy Techniques To Mastering Oil Painting!

You will also discover that two colors mixed together will not look the same if they are applied in two separate overlapping layers. This is the reason that at times, you will need to wait for the first layer to dry a bit before you apply the next layer to achieve a certain color or texture. It is important for a beginner to know these qualities of oil paints for a successful painting project.

Materials Used in Oil Painting

- **Oil Paints**
 Oil paint is a type of paint that consists of a colored powder mixed with a drying oil. The most popular drying oil is linseed oil. The drying oil makes the paint dry slowly. You can buy ready to use oil paints in various colors.
- **Viewfinder**
 A viewfinder is a sighting tool that helps you create a frame for your object, just like a viewfinder on a camera. You can make one by cutting a window out an index card. The outer layer will serve as your frame. The items you see inside its window will be the same item you will paint in your canvas.
- **Canvas**
 A canvas is commonly used fabric used for painting. The fabric is usually placed in a wooden frame.
- **Easel**
 It is a self-supporting wooden frame used to hold the canvas while it is being painted or drawn.
- **Palette**
 A palette is a thin board where oil paints are mixed. It can be made of wood, plastic, ceramic or other materials. It also comes in different sizes and shapes
- **Different sizes of paintbrush**
 A paintbrush has bristles, a handle, and a ferrule. Brushes come in different sizes, shapes and have different types of bristles.
- **Palette knife**
 The palette knife is a thin steel blade with a handle and is used for mixing colors and applying or removing paint.
- **Paint thinner, turpentine, solvent or linseed oil**
 These liquid materials are used to adjust the consistency of the oil paint.

Oil Painting: 1-2-3 Easy Techniques To Mastering Oil Painting!

Chapter 2. Fundamentals of Oil Painting

Before you start painting, familiarize yourself first with the basics of the painting process. This means that you should study the basic shapes and colors of an image before getting into the details.

Basic Painting Process

One of the main qualities of oil painting is applying paint in layers. The first step in oil painting is to sketch in the different parts of the painting using a wash. A wash is a pale color that is made by mixing an oil paint with a solvent.

After making the sketch, apply paint in the major light and dark areas. Adjust the colors and shapes by starting with a thin layer of paint. Gradually apply thicker layers of paint to let the colors in the lower layer's peek through.

Below is a more detailed instruction of the steps:

1. Create a sketch.
 The initial marks on a canvas make up the drawing using a wash. A wash is a thin mixture of paint and solvent that is fast drying and easy to modify. You can easily make changes to your drawing at this stage. Do not use a solvent to erase or clean marks because it will just create a mess. The best way to correct part of the sketch is to wait until it slightly dries and paint over it.

2. Choose your plot.
 After you outlined the image on the canvas, you will be able to foresee the outcome of your painting. At this stage, you should still be able to make changes and improve the overall design of your painting.

3. Apply the major colors.
 Once you have finalized your design, you can block in the major colors. You can adjust on the object of your painting as you apply the major colors. Your painting takes on a more substantial appearance as you apply more colors.

4. Paint in layers.

Oil Painting: 1-2-3 Easy Techniques To Mastering Oil Painting!

With the basic colors in place, you can start applying heavier paint to your objects. The succeeding layers can be of the same shade of color or you may adjust it to depending on the effect that you would like to bring out in the painting.

Brushes and Brushstrokes

Brushes come in different sizes and shapes. They are usually long enough to allow you to vary the brushstrokes just by changing the way you hold the brush. For instance, if you hold the brush down by the ferrule, you use the small muscles of your hand and fingers and have fine control over the strokes. On the contrary, if you hold the brush farther away from the ferrule, you have a looser hold on the brush for loose, expressive strokes. The ferule is the metal part of the paintbrush that olds the bristles and the handle together.

Different Brush Sizes and Bristles
- Short and square-ended paintbrush makes square corners and tight edges. This brush is great for geometric shapes or manmade objects.
- Long and floppy filberts make elegant, organic, lozenge-shaped marks. This brush is perfect for organic and natural objects.
- Sable or synthetic fibers are more delicate than the bristle brushes and leave less of a mark.

Different types of Paintbrush
1. **Filbert**
 Filberts are used this to paint leaves, clouds and other living things and natural organic forms.
2. **Flat**
 This paints large areas of color. This type of paintbrush is also best for painting geometric forms and filling out square corners because it gives a clean crisp edge.
3. **Bright**
 This brush is like flat the only difference is that it is shorter, broader and holds less paint.
4. **Round**

Oil Painting: 1-2-3 Easy Techniques To Mastering Oil Painting!

This is great for drawing lines.
5. **Fan brushes**
 The fan brushes are used for fine blending.
6. **Extra-long filberts**
 You can use these to make very loose and expressive marks.
7. **Stencil brushes**
 You can use a stencil brush for dry brush. They are chubby and round.
8. **House painting brushes**
 Use them for big projects and for dry brushing.
9. **Foam brushes**
 You can use them pick up excess paint.
10. **Painting knife**
 This like a palette knife but it is more rigid. You can use it as a trowel to pick up paint and apply it to the canvas.

Different Glazing Techniques

A glaze is a transparent coat applied to create an illusion of a third color. It is a thin layer applied over another color. Glazing refers to any type of painting that allows you to see two different colors at the same time. You can see this definition in layers of color thinned with medium. You can also see it when paint is marked in small spots of color.

- **Imprimatura**

 This Italian term means that you start with a colored background. The typical background of a painting is white. However, there are instances wherein you will start your painting with a colored canvas. If you have a colored canvas, paint it with a fast-drying coat to bring out the undertones. Allow the area to dry a bit before you wipe away some of the paint. Create the light areas of your image by wiping them with a rag or a dry paintbrush. Let it dry thoroughly before you proceed with your painting. This technique is like using an eraser to pull out the light areas of the drawing rather than laying in dark areas.

- **Scumbling**

 It refers to removing a thin layer of a paint by applying an oil paint on it. You scrape off the excess paint until just a tiny part of it is left. This

technique works well with dense colors especially if a light color is applied over a dark color.

- **Sgraffito**

 This is like scumbling; the only difference is that with sgraffito distinct marks are left. You can use this technique if you want to show defined textures or ragged edges.

- **Dry Brush**

 This technique is done on a dry part of your painting. Lightly brush over the painting using a stiff, dried paint on a dry brush. This works best and produces more specks on a rough and textured surface rather than on a smooth surface.

- **Impasto**

 This is the process of painting using a thick paint. This helps to add texture to the painting. You can use a regular oil paint or a ready to use impasto medium.

Oil Painting: 1-2-3 Easy Techniques To Mastering Oil Painting!

Chapter 3. Master the Art of Mixing Colors

Mixing and matching colors can be overwhelming. Mixing colors is an essential technique that every beginner must learn. Most beginners think that the best way to make something look darker is to mix it with black and to make something lighter you mix it with white. These color combinations though will not help you achieve your desired color.

The best way to learn about colors is by creating a color chart and knowing the color wheel. That way, you will discover how to make light and darks using other colors instead of just using black and white. This technique will keep you from making the mistake that most beginners commit which is creating cloudy colors. By making a color chart or wheel, you will learn how to mix the colors and begin to get a feel for applying paint to the canvas in a uniform manner.

Color Terminologies

It is important that before you make a color wheel or chart, you are familiar with the color terminologies to avoid confusions.

- **Primary Colors**
 These are red, blue and yellow.
- **Hue**
 Hue is the name of the color, such as red, green, blue, or another color. A pure hue is the brightest version of a color.
- **Tint**
 A tint is a lighter version of a hue. You make a tint by adding white to a pure hue.
- **Shade**
 A shade is a mixture of the pure hue plus black. Another way to make a shade is to use the hue's complement rather than black in these mixtures.
- **Complement**
 It is the hue directly across the color wheel from the hue that you are working with.
- **Tone**

It is a mixture of a shade plus white, or you can think of it as the pure hue plus black and white. You can also use the complement rather than black in the mixture.

Color Illusions

Once you have mastered the color wheel and the art of mixing colors, you must also familiarize about the effects of colors with each other.

- **Value and Size**

 A color in a smaller area will seem darker and brighter. An example would be the color on the cover of a paint can, if you paint an entire room with it, you will notice that the color appears lighter compared to how it appears on the cover of the can. The smaller the area that a color covers, the darker it appears.

- **Value**

 A color surrounded by a lighter color appears to be darker, but if it is surrounded by a darker color, it appears to be lighter.

- **Hue Effect**

 A color surrounded by one of its primary hues appears to be more like its other primary pure hue.

 For instance, you want to use violet in a paint. Violet is made of the primary colors red and blue. If red surrounds a violet paint, the violet paint would look like it has more blue in it. On the contrary, if blue surrounds violet, the violet paint would appear as if it has more red in it. Though, the two violets are of the same concentration.

- **Intensity**

 Complementary colors placed next to each other make each other look brighter, but similar hues make each other look duller. On the other hand, any brighter color makes another color look darker, and any dark color makes another color look brighter.

Chapter 4. Monochromatic Painting

Start with Black and White Paint

Black and white painting is a type of monochromatic painting or also known as under-painting. Monochromatic painting just uses one color or hue but in ranging values, from light, medium to dark. In black and white painting, you use different values of gray (a combination of black and white) to create your painting.

Starting your oil painting adventure in black and white makes it less overwhelming. However, it's a good way to practice as it gives you the chance to use oil paints and see how they work. This exercise is like creating a sketch.

- **Find a Still Subject**
 Look for things that are plain and simple. Choose two to three items and group them together but do not place them tightly close to each other. Place your objects in an area that will let them cast shadows.
 Arrange your objects so that the areas around them make remarkable shapes as well.

- **Draw the Initial Sketch**
 Do not use a pencil to draw the sketch on your canvas. Use a wash or a pale paint to draw your sketch. A wash is a pale color of your paint. You can create a wash by directly mixing a pool of gray oil paint in a jar of a solvent.

 Another way is you squeeze out a pool of white and black paint on your palette. Then take a small part of your white and black paint using a palette knife to create a gray mixture. Dampen a round brush with a solvent and knock off the excess solvent. Take a small amount of the gray paint. You will still end up with a wash of gray because of the solvent on the brush.

Sketch your outline using the gray wash. If you need to make corrections, use a darker shade of gray.

- **Sighting and Measuring**

 Sighting is a way of checking to see whether your objects are drawn properly. You can use your paintbrush handle to compare the actual object to the painted object. You can do this by closing one eye and holding out your paintbrush handle at arm's length and visually lay it along the edge of the item to get the angle that you are trying to draw.

- **Block Major Shadows**

 Locate the shadows of your object. Dip a brush in solvent and take some of the gray wash used for the initial sketch. Apply paint on the dark side of the objects.

- **Develop the Image**

 The basic rule of painting is that you start with the main objects first and secondary areas like the shadow and then the background. When you develop the image, you need to mix three shades of gray and use a different paintbrush for it. Using a palette knife, create a light gray, medium gray, and dark gray. Apply the medium gray first on the middle areas. Use the light grey in areas that are closer to the light and the dark gray to the shadows. As you paint the entire canvass, you can make adjustments on your objects to achieve a more polished image. It is important not to leave any part of the canvass unpainted because it will eventually turn to yellow that would ruin the effect of your painting.

Oil Painting: 1-2-3 Easy Techniques To Mastering Oil Painting!

Chapter 5. Paint Local Colors Using Analogous Colors

Analogous means identical or similar. You can practice painting objects by finding its analogous color in the color wheel. It can be difficult to paint objects in colors particularly for beginners. For this painting, do not use black and white colors. You use complementary colors to make something appear darker.

To practice your painting skill, start with painting a green apple, an orange and a lemon. Objects that are medium or light in color are best for this exercise. For the background, use a blue cloth.

Frame and sketch

Use a viewfinder to frame your scene and sketch the objects using a wash. Make a wash of the color with your solvent, and use the wash to draw out the objects. Make the objects nice and big or at least life-size.

You can adjust your drawing by choosing a color slightly darker that the first. Using a different color helps you keep track of which line to use when you begin to develop the painting.

Find the local color

The local color is the natural color of an object as it appears in normal light. Look at the objects you have and ask yourself what colors they are. The green apple is more yellow-green than green; the orange is orange; and the lemon is yellow.

Paint the Orange

Now mix a small pool of color to match the local color of one of your orange. You may have to adjust the actual color by using more yellow or red to get the right color.

Oil Painting: 1-2-3 Easy Techniques To Mastering Oil Painting!

To match color perfectly, put some of your paint on your palette knife and place it next to the object. Make sure that you hold it up to the side of the orange that is closer to the light. If you see a color in the object that is missing on the knife, add that color. For example, if your orange fruit looks more yellow than the paint on the knife, add yellow; if it looks more reddish, add red. Experiment with the colors to get the right one. It takes practice to master color combination. Just try and try and add just a little bit at a time until you get it right.

1. **Choose analogous colors.**

Find the color that comes the closest to the color of the orange in your still life. In this case, it will be orange. Look also for tubes of oil paints that match the color of the other parts of your orange and put them on your palette as well. You do not have to mix anything at this point. Just place the oil paints next to each other in your palette. Squeeze out small amount of yellow, red, yellowish-brown, and crimson.

2. **Begin applying the color.**

Take the orange paint that you made and apply a thin wash to the orange on your canvas. Cover the middle and shaded side of the orange with this color. As you get to the part of the orange that is lighter, pick up some yellow with the same brush and add it right to the canvas. It will look yellow-orange. You can also add pure yellow to the exact point where the light hits the orange.

For the shaded side, make a color that is more red-orange. Use a fresh, clean brush to apply it to the underside of the orange on your canvas. Now your orange fruit is orange with yellow highlights and a red-orange shaded side. You can use a red that has a bit of crimson for the very bottom of the orange.

3. **Do not blend the colors in applying the paint instead apply them in a block.**

Paint the Lemon

The lemon is a little tricky because its local color is bright yellow. It is the lightest color on the color wheel, so it functions as the highlight. With yellow objects, you should figure out which direction to move on the color chart to find the analogous

color to create a shadow of yellow that looks like it belongs on a lemon. Paint the entire lemon with yellow and then move on to the shaded side.

Your analogous color options are green and orange. When you look closely at the lemon on the shaded side, you notice that it looks greenish on the darker side. So, use yellow for the highlight and yellow-green for the shaded side. Experiment with different greens for your lemon.

Paint the Green Apple

The apple on your sketch will be round, but you know that the shape of an apple is significantly different from an orange. The stem comes out on the top through a hollow part.

Using a yellow wash for your drawing, adjust the shape of the apple. Find the little indention at the top of the apple, and use your yellow to make a mark. Change it with the next analogous color, like yellow-green. Use yellow to establish the structure of the apple by making a line right through the middle of the apple as if you are stabbing it. Draw an ellipse on the top of the apple and then make a second ellipse to mark the shoulders of the apple.

The local color of the green apple is yellow-green. The apple also has yellow highlights and a green-shaded side. Use yellow, and a tiny bit of both ultramarine blue and cerulean blue.

Find the shaded side and paint it in with a thin wash of yellow-green. Continue to fill in the lights with yellow and the shaded side with green. The green is in the top indention and off to one side of the indention. Use yellow or a lighter version of yellow-green to fill in the lightest part of the green apple.

The Background

Identify the local color of your cloth first and find its analogous color. Find all the blues, blue-greens, and blue-violets that may work for your cloth. The shadows cast by the objects onto the cloth are a darker version of the color of the cloth; they have nothing to do with the color of the object casting the shadow. Take the

color of the cloth and the color for the cast shadows and apply them to the painting in a thin wash.

Paint Shiny Objects

You have learned previous how to apply colors. You already know how to use colors to create a three-dimensional form. However, you have yet to learn how to paint objects that are more complicated. These are the shiny objects like a metal and a glass. In painting a shiny object, you must learn how to capture its glimmer and glow.

Paint Metal

Start with a simple metal subject like a tin can. You can find it anywhere and it is very easy to draw in terms of shape. You can paint an image of the can by itself, or make a small still life with the can. Place the can on a surface with some color and experiment with the lighting and placement of other items around the can. The other object near the tin can will show their reflection on it. Place a brightly colored object nearby like a box, and play with the reflections.

Your still life set up should be about 2 to 4 feet away from you. You should have good lighting for the objects that you are painting. This painting takes more than just one session. Make sure that you can leave your setup in one place without having to move the items.

Steps to Draw the Tin Can

Start by drawing the tin can and any other objects in your setup on the canvas. Sketch the can, its cast shadow, and the box with light sketchy lines so that you could easily correct them.

Draw the tin can by making ellipses for the top and bottom and then connect them for the sides. This step uses the transparent construction method. The tin can be just a cylinder with ribs. You can make the ellipses by keeping your hand steady as you make a circular motion using your upper arm. Make several ellipses at the top and bottom part of the can.

Oil Painting: 1-2-3 Easy Techniques To Mastering Oil Painting!

Then draw the ones in between. Make sure to create an even space for the ribs. Keep your hand steady and try to mimic the ellipses that you drew for the top and bottom of the can. Draw the entire ellipse even though you see only the forward edge in the finished painting. When you fill in the other ellipses, they will look stacked. This creates the ribs of the can.

First Session

1. Find the patches of color.

 When you look at the can, you see gray, but you also see the reflection of other colors. Look at the shapes and patterns of the different values and colors in the can. Try to see it as a paint-by-number painting where you have larger shapes of color that break down into smaller shapes. In the tin, can, you also see bands of colors that move around its contour.

2. Apply the local colors that you see in a thin wash.

 The pattern of the ribs of the can should have light and dark colors which creates a series of dashes. Across the ribs of the can, they stack up like bricks. Do not blend colors, just paint by block using the patterns that you see on the can. Painting metal is about painting patterns. Painting without blending is what makes metal look like a metal.

3. As you paint, look at the can and examine the reflections that you see on its surface.

 Identify the items on the reflection to help you to help you identify the colors that you see on the can. Add the reflection in the dashes along the ribs and be sure to match the color to its nearby source.

4. Make alterations and continue to develop the patterns by using the colors that you see and add them in spots and patches. After you have all the colors blocked in, you can set the canvas aside to dry a little before you continue.

Oil Painting: 1-2-3 Easy Techniques To Mastering Oil Painting!

Second Session

After a day or two, you can continue with the next session. Some parts of the painting may feel completely dry while others may have started to develop a sticky surface. They will be wet again as soon as you add more paint. This allows you to blend and mix your colors right on the canvas.

Whenever you spend more than one session on a painting, you must use a drying oil medium rather than solvent. A painting medium allows the painting to dry properly. It adds back in a little of the linseed oil that the solvent dissolves out. It allows you to paint with smooth strokes and to blend and it slows the drying time of your painting. If an oil painting dries too quickly, it damages the layers of paint, causing the surface of the painting to crack.

You can make your own medium or you can use a commercially prepared painting medium. Use the painting medium to wet your brush as you work. The medium makes your paint fluid and creamy. It is very different from working with plain solvent, which can make your paint drippy and watery. The oil in the medium also helps to remoisten the previous layers, which allows the new layers to bond with the previous layers.

Continue to apply paint to the canvas, gradually building up the layers. Try to work with patches of color to develop, and refine patterns of value and colors as you work.

If you have an area that you should blend, experiment with blending in a finite area to get the hang of using the medium. Refrain from using blending if you can to help you maintain clear edges and convincing reflections.

Continue to apply a new layer of paint to all parts of the canvas, developing the image as you go.

Finish off the painting by adding the glints of light on the surface of the can. These glints are white and may stand up pinpoint-like from the metal. In creating these glints, just take up a little dab of something white – (even something slightly off-white would do) using a small dry, brush with no solvent on it at all. Just touch the brush to the point you need and leave it alone.

Oil Painting: 1-2-3 Easy Techniques To Mastering Oil Painting!

Paint Glass

A glass is a challenging object to paint for beginners because it is transparent yet it reflects image at the same time. It catches the light and reflects it back to you. It can also include dark spots. You can also pick up reflections on the surface of the glass from objects in the room.

To practice painting a glass, start with a simple object like a regular wine glass with no ornaments. Does the same thing as you would do before you start painting. Lay your object on a background and frame your still life using a viewfinder. Once you have framed your still life, sketch the bottle using a wash.

First Session

1. Find the three largest shapes in the glass, and draw them in.
 Sketch in only the largest shapes now. As you establish the major shapes in your glass, try to identify the sources of the reflections that you see. For instance, if you see the reflection of a box in your glass, notice how the glass distorts its shape.
 Try to maintain the same viewpoint to capture the shapes more easily. In painting glass objects, every time you move, the shapes of the reflections in your object change as well.

2. Mix washes for the color of the wine glass and the other parts of your setup area.
 Concentrate first on the largest shapes. Notice that some areas inside the wine glass are a mix of both the color of the wine glass and the color from behind it. Make up these colors and apply them as you see them.

3. After you block in the major shapes in the glass, find the medium shapes and then the smallest shapes and block them in.

4. Continue to develop the other parts of the canvas so that you have a consistent surface over the whole painting.

Oil Painting: 1-2-3 Easy Techniques To Mastering Oil Painting!

Second Session

After a day or two, polish the application of color to the glass using a painting medium. You can apply a relatively thick application of paint to make your wine glass look more fluid and more glass-like. Find the highlights and apply them with tiny points of white paint. If a light reflection on the glass is relatively big, apply a big patch of white on it instead of tiny dots.

Oil Painting: 1-2-3 Easy Techniques To Mastering Oil Painting!

Chapter 6. Painting a Portrait

Painting a portrait is one of the most difficult things that you can do. You must be keen in observing the many details that a human face has. If you are unable to capture certain details of a human face, the result will not turn out like your subject.

Although painting portraits can be a bit frustrating in the beginning, with practice you can develop the skills necessary to create a true likeness.

Practice Sketching the Proportions of a Face

You might already be familiar on how you set the outline to check the proportion of a face. It starts with by drawing an oval shape. Then you divide it up for placement of the eyes, nose, mouth, and so on. If you have never tried making a portrait before, you can practice drawing the features of the face first. You can start by drawing the different features of the face. You can draw from photos or from your image in the mirror. Practice drawing eyes, noses, and mouths until you feel comfortable with them.

You can start practicing the proportions of the face by following the steps:

1. Get a real-life picture of a person. You can use your own picture if you want. Just make sure that picture is life size or big enough for you to see the details.

2. Draw an oval on the canvas and look at the picture.

3. To measure the head, take one of your long paintbrushes and put the handle right down the middle of the face, touching the nose. The top end of the brush must stop exactly at the point at the top of the head. Get the measurement from the top of the head until the bottom part of the chin. You can use a ruler, if you find it more comfortable.

4. To find the eye level, measure from top of the head to the middle place between the eyes. Mark your eye level on your oval.

5. Place the handle so that it measures from your eye level to the chin and find the point for the base of the nose; mark this point on the oval.

Oil Painting: 1-2-3 Easy Techniques To Mastering Oil Painting!

6. Do the same for the position of the mouth, using the opening of your mouth as the measuring point.

Find the best point of view for a portrait

Portraits come in different positions and different styles. You will see some portraits wherein the head of the person is slightly tilted to one side, and some with just the face; others include the full body, and the list goes on.

Here are three of the most commonly used types of portraits that you can choose from:

- **Profile Portrait**
 A profile is the easiest point of view to portray, because most of the resemblance depends in the contour of the face. Profile paintings are more like mug shots but profile portraits generally do not include the front face. The main concern of the profile is face of the person

- **Full-face Portrait**
 The face of the person portrayed is directly facing the viewer. This type of portrait is the most difficult because the nose is directly pointing at the viewer, which makes it very hard to capture.

- **Three-quarter View Portrait**
 Three-quarter view is falls between the profile and the full-face portrait. This makes the subject look more natural.

For a beginner, the best option among the three would be the three-quarter view. To practice in painting a portrait, it will be best to start drawing a portrait of yourself. All you need is a mirror and you can position yourself in any way you want.

So, to start this activity, place the brush before your nose and turn your head a quarter. For this exercise, turn to your left. Notice how the eye, nose, and mouth level are the same, but your centerline is off to one side. Your centerline is curve and it follows the contours of the face. This curving line starts in the middle of

your forehead and ends in the middle of your chin. It gently bends to the left to follow the line of the nose. The right cheek is a wide surface, but the left cheek is reduced.

Find the relative position of your facial features using your paintbrush handle. Hold it horizontally or vertically and see what parts of your features line up with others.

A Self-Portrait in Black and White

It is a good start to learn and study portraits by drawing a self-portrait because you get to paint whenever you want and virtually wherever you are.

Now the reason that you should start with black and white self-portrait is to simplify things. Master first the art of drawing the different features of your face and then just worry about adding the right colors later.

Work through the following steps to get started:

1. Gather your supplies.
 You need a canvas that is big enough to paint life-size face, a mirror, black and white paint, different types of paintbrush, solvent in a couple of jars, a palette, and a palette knife.

2. Set up your mirror and materials.
 Make sure that you have a three-quarter view of yourself in the mirror. Position a clear light source directed at your face from the side. You need a light source to see the contours of your face. A lamp or a bright window works well.

3. Create your wash.
 Mix up some light gray paint to make a wash and draw an oval on your canvas. Draw the proportions of your face. Your oval must be of the same size as your face to make it easier for you to paint.

4. Make a light line for the level of the eyes, nose, and mouth, and draw the location of the hairline. Check your work and make any necessary corrections.

Oil Painting: 1-2-3 Easy Techniques To Mastering Oil Painting!

Draw the big contour of the face

After drawing in the proportions of your face, draw a line for the outline that you see on the far side of the face. This contour line is important for finding the placement of the facial features. Follow these steps to find the outline of your face:

1. Begin from the top of the forehead, and curve the line outward to the brow.

2. Dip the line in to follow the hollow of your eye socket.

3. Make a curve line out for the cheekbone and down along the line of the cheek then gently curve in to the chin.

4. Connect the line of the chin in to join the neck. Do not worry if the chin extends beyond the initial oval that you drew.

Fill in the back of the head

The next step is to add some volume to the back of the head.

1. Draw a circular shape from the top of the head near the hairline. Make sure that the line will connect the head with the bottom of the ear. Just make an approximate line of your hair hides this part of your head.
2. Line up this point to the level of the lip line to be more precise.
3. Draw in the outline of the neck under the chin and draw another line from the back of the head.

Work on the contour of the nose

Create the outline of your nose by making another line with your wash. You draw this from your left eyebrow to the base of your nose.

Follow the steps to draw the contour of your nose:

1. Start at the point that is close to the contour of the side of your face. This is the part where the eyebrow extends the farthest.

2. Follow the contour of your eyebrow to the bridge of your nose. Then continue down to the angle of the nose until you reach base of your nose.

3. Add your philtrum. The philtrum is the vertical indentation between the base of the nose and the border of the upper lip.

Add in the features

Now, you add and enhance the other features of the face like the eyes and the mouth. When you draw an eye, the shape resembles to an almond with a round dark shade in the middle and a black dot for the pupil. However, the shape of the eyes look different in a three-quarter portrait which means that you also need to have a different approach to capture them.

Below are the steps to draw an eye for a three-quarter view:

1. Locate the iris of the eye on the far side of your face and put it in using the contour of the nose to help you place it. Your iris should appear as if it is tucked into the bridge of your nose.

2. Then draw your eyelids exactly as how they appear.

3. Draw a line to help you locate the corner of the lips. The far side of your lips should be smaller and the nearside will appear to be a bit bigger.

4. Find the points for the corners of the mouth, and then locate the centreline. Connect the two corners of your mouth using a line. The centerline of your mouth is a continuation of the philtrum.

5. Use the near corner of your lips as a guide to line up the position of the near eye. The corner of the near eye is above the corner of the mouth.

6. To help you find the width of your near eye, measure the base of the nose and the width of the mouth.

7. Check the position of your own face and make necessary adjustments on your painting to refine your features.

Oil Painting: 1-2-3 Easy Techniques To Mastering Oil Painting!

Develop the lights and darks of your face

1. Mix three pools of gray paint in different values. You must have a mixture of light gray, medium gray and dark gray. Use a different brush for each mix to avoid color contamination.
2. Find the shaded or dark part of your face and paint the dark gray in those areas.
3. Find the lightest areas of your face gray and paint them with the light gray. Do not blend, just work up the face in patches of light and dark gray.
4. Fill in the middle tones using the medium gray.
5. Cover the rest of the face with the appropriate grays.

Colored Self-Portrait

There are different types of skin tone and every individual has a different skin tone.

Flesh Tones

The human skin has the colors of the primary colors. As you work with oil paints, you will find out that a natural brown is a product of blues, yellows, and reds mixed in the right proportions. You can come up with various skin colors by varying the ratio of the three primary colors, and adding white.

Below are the colors mainly used for flesh skin tones:

- **Yellow**
 Yellow is widely used painting portraits. If you want dark skin, you may use raw or burnt umber.
- **Red**
 Crimson works best for a dark skin tone while red is best for a florid complexion.
- **Blue**
 Deep blue dulls the brilliance of the orange and when you mix the blue and orange, the hue would look for natural.
- **Titanium white**
 When it comes to skin tones titanium white is the best white to use.

Oil Painting: 1-2-3 Easy Techniques To Mastering Oil Painting!

Skin Formula

The skin has two basic tones: the light tone and the dark tone. Once you know the basic color combinations that make up these tones, it will be easy for you to come up with a more natural-looking skin.

- **Lighter Skin Tone Formula**
 Start by creating bright orange or you use a ready to use orange oil paint. To create a bright orange, mix yellow and red. Compare the shade of orange with the skin tone you are painting to see if you need to add more yellow or more red. You can adjust the hue by adding white to achieve a tone similar you what you see on a real person, with the lower portion of the check or and the inside of the arm lighter. You will notice that the mixture will be very light and odd to be a skin color. Now to make it look more like a natural skin color, you can add blue.

- **Darker Skin Tone Formula**
 Start with an orange oil paint. You can use an oil paint straight from a tube but the thing about it is, you will still be needing to make adjustments to it anyway so might as well just mix your own orange color. Compare your orange to the skin tone that you are painting. Check if they both lean toward yellow or red.

 Add blue to darken a skin tone or tones you can also try raw and burnt umber. Again, for lighter more natural-looking color, you can add white.

You will notice the colors used for both light and dark tones are the same. The only difference between the two is the ratio of the colors used.

One of the common mistakes of beginners is that they rely too much on white to achieve a light skin tone. When one uses too much white it makes the skin tone too pale and looks unnatural. Adding orange to it makes it more natural looking.

Normally the color of the skin of a person changes when exposed to a bright light. The color of the skin is warmer when it is lighter and cooler when it is darker. Therefore, when you paint a portrait of a person, you might just be using one tone but it will have different values as well.

Oil Painting: 1-2-3 Easy Techniques To Mastering Oil Painting!

Since you have already practiced how to make a self-portrait in black and white and you already know the basic formula for skin tones, you can now start making a colored self-portrait. Incorporate everything that you have learned from blocking in the shaded part of the painting to mixing colors and making a self-portrait.

You should also be more confident now to try other objects for your next oil painting project. Incorporate everything that you have learned in this book. Apply the basic knowledge in blocking in the shaded part of an object, different glazing techniques to make corrections, and using complimentary colors to add more complexity to your painting.

Conclusion

Thank you again for downloading this book!

I hope this book could help you gain confidence in trying oil painting. With everything that this book has imparted you, oil painting should no longer scare or intimidate you.

The basic techniques, discussed in this book should help you resolve your reservations in oil painting. It might be a complicated process but with sufficient knowledge and continuous practice, becoming comfortable with it is not impossible.

The next step you need to do is to buy your supplies and start painting.

Finally, if you enjoyed this book, please take the time to share your thoughts and post a review on Amazon. It'd be greatly appreciated!

Thank you and good luck!

www.ingramcontent.com/pod-product-compliance
Lightning Source LLC
Chambersburg PA
CBHW061221180526
45170CB00003B/1098